size
matt
ers

Published on the occasion of *Size Matters*, an Arts Council Collection exhibition toured by National Touring Exhibitions from the Hayward Gallery, London, for Arts Council England

Exhibition tour:

19 March – 5 June 2005
Longside Gallery, Yorkshire Sculpture Park,
Wakefield

1 July – 20 August
Millais Gallery, Southampton Institute,
Southampton

27 August – 9 October
Djanogly Art Gallery, Lakeside Arts Centre,
Nottingham

1 April – 21 May 2006
Gallery Oldham,
Oldham

Tour continues

Exhibition organised by Natalie Rudd
with the assistance of Clare Jackson

Catalogue designed by SEA
Printed in Germany by Passavia

Art Publisher: Caroline Wetherilt
Publishing Co-ordinator: James Dalrymple
Sales Manager: Deborah Power

Front cover: Hiraki Sawa, *Dwelling*, 2002 (still)

Published by Hayward Gallery Publishing, Belvedere Road, London,
SE1 8XX, UK. www.hayward.org.uk
© Hayward Gallery 2005
Texts © the authors 2005
Artworks © the artists or estates of the artists 2005 (with the exception
of pp. 58 – 59: © Dieter Roth Estate 2005)
Photographs: Prudence Cuming, Mike Fear, Hugo Glendinning, Jerry
Hardman-Jones, Graham Matthews, Stephen White, Jonty Wilde and
Hermione Wiltshire

Hayward Gallery Publishing titles are distributed outside North and South
America by Cornerhouse Publications, 70 Oxford Street, Manchester M1 5NH
(tel. +44 (0)161 200 1503; fax. +44 (0)161 200 1504;
email: publications@cornerhouse.org; www.cornerhouse.org/publications).

For further information about works in the Arts Council Collection, please
write to the Head of the Arts Council Collection, Hayward Gallery, SBC,
Royal Festival Hall, London SE1 8XX.

size matt ers

Exploring Scale in the Arts Council Collection

Arts Council Collection
Hayward Gallery
South Bank Centre, London

Contents

Pre
face

Everything is relative. Despite the fact that the Arts Council Collection has acquired over 7,500 works since it was established in 1946 – making it the largest loan collection of post-war British art in the world – it shares the same principal as any other collection of objects: it is a microcosmic sample taken from the macrocosmic world at large. Selecting an exhibition from the Collection depends on a further process of discrimination and reduction; as the rationale becomes tighter, the number of works shrinks from 7,500 to around 30 – a tip of the iceberg. *Size Matters* is one such fragment from the Arts Council Collection, one that investigates the impact of scale on recent art practice.

Paradoxically, scale is so fundamental to visual art that it is often overlooked. The fascination with superficial likeness has perhaps, in the past, prevented the viewer from seeing that an awesome landscape has been shrunk to fit a small canvas, or that a statue of a noted individual is five times larger than life. Such oversights have not escaped the attention of artists working today: many have examined the very processes of miniaturisation and enlargement to create works that reappraise the relationship between scale and context, form and function. *Size Matters* illuminates these developments by presenting a broad selection of recent paintings, sculptures and films featuring recognisable objects faithfully represented, save for a radical shift in scale. Displayed together, the works create a unique environment, one that prompts us to ditch our assumptions about scale at the gallery threshold, leaving space for fresh perspectives.

Size Matters was conceived and selected by Natalie Rudd, Sculpture Curator of the Arts Council Collection, who is based at Longside,

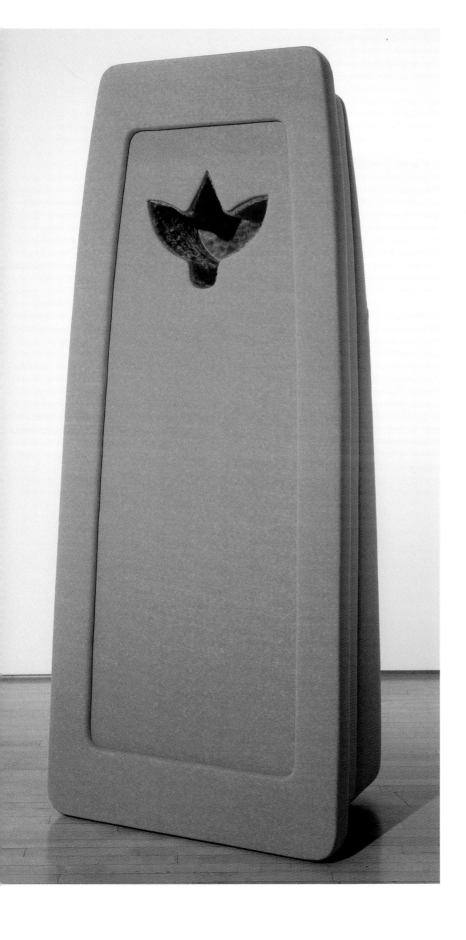

Eric Bainbridge
In Heliotrope, 1990
Fur fabric, fibreglass and plywood
223.5 x 93.5 x 59 cm
Purchased from the artist, 1993

Jordan Baseman
Boy, 1995
Cotton and metal
103 x 67 x 2.5 cm
Gift of Charles Saatchi, 1999

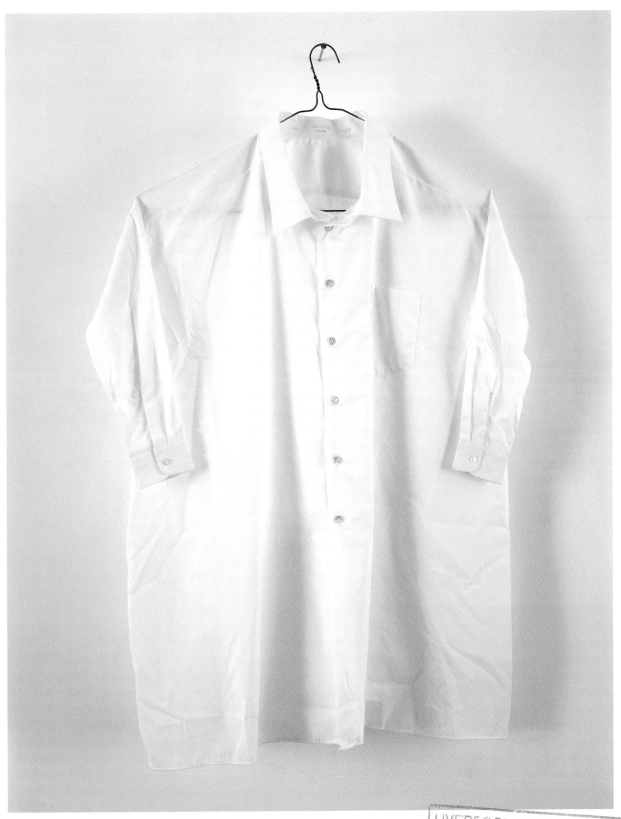

Sara Bradbury
Chairs, 1999 (installation details)
Clay, garden wire and enamel paint
180 parts, each 6 x 3 x 4 cm
Purchased from the Annual
Programme, Salford, 2000

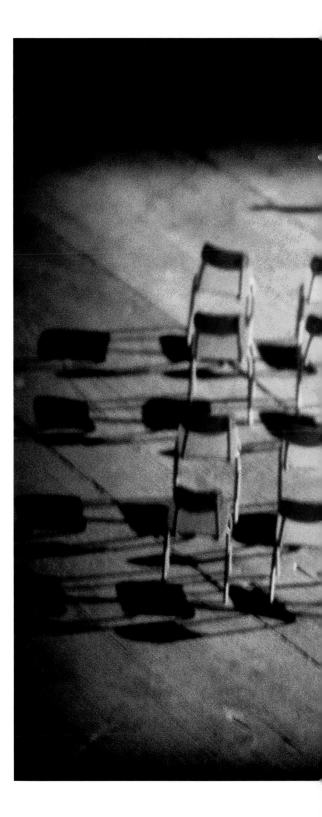

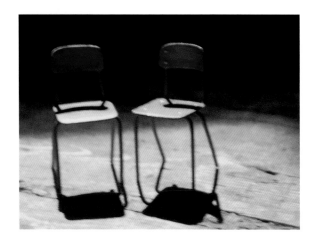

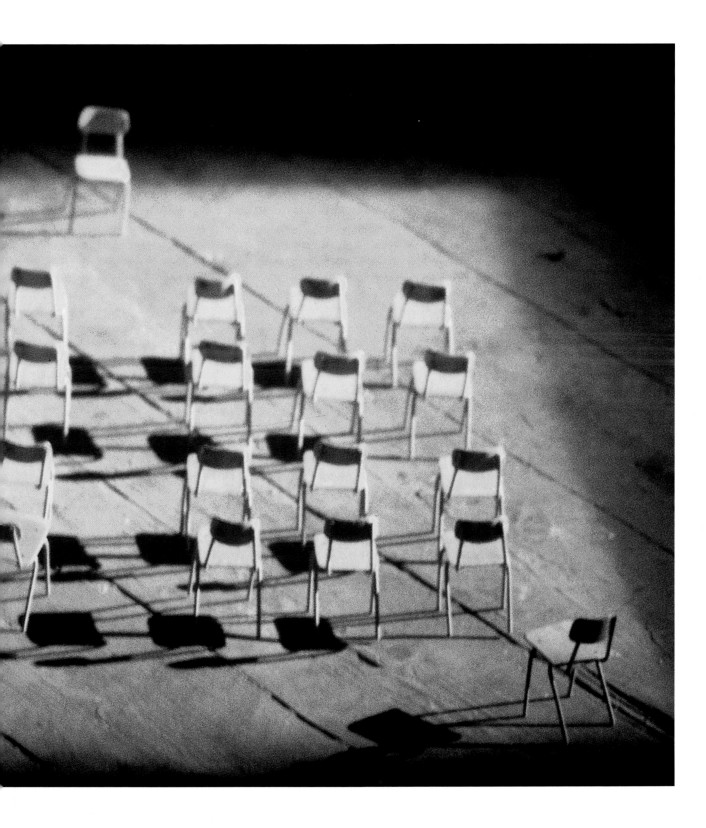

Martin Creed
Work No. 78, 1993
Elastoplast, polystyrene, paper and cardboard
2.2 x 6.8 x 4.9 cm
Edition 12 of an unlimited edition
Purchased from Marc Jancou Gallery, 1994

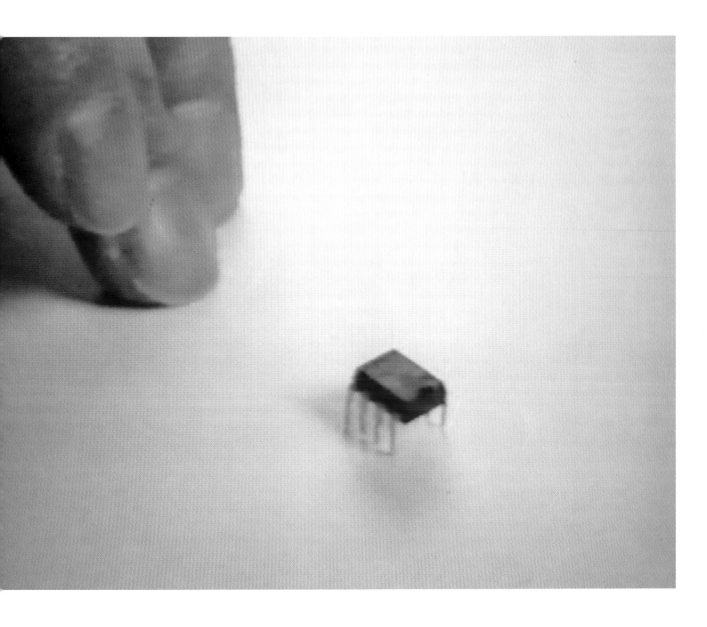

Alan Currall
Word Processing, 1995 (still)
Betacam SP video tape
Running time: 6 minutes, 21 seconds
Edition 2 of 5
Purchased from the artist, 1997

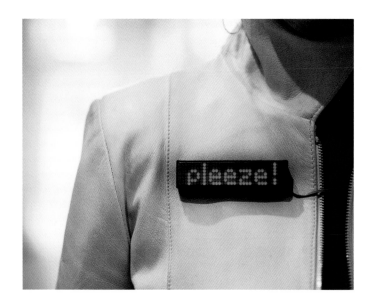

Rose Finn-Kelcey

above:
House Rules, 2001
Miniature circuit board, red LEDs
encased in vacuum-formed plastic, battery
and mains connection
2.3 x 9.4 x 1.7 cm
Purchased from The Multiple Store, 2003

right:
Jolly God, 1997
Wool, lime, latex and wood
290 x 360 x 10 cm
Purchased from Camden Arts Centre, 1998

Leo Fitzmaurice
Holland, 1995
Acrylic on wood
2 parts, each 5 x 14 x 5 cm
Purchased from the artist, 1995

Laura Ford
Giraffe, 1998
Plaster, steel and fabric
670 x 500 x 100 cm
Purchased from Camden Arts Centre, 1999

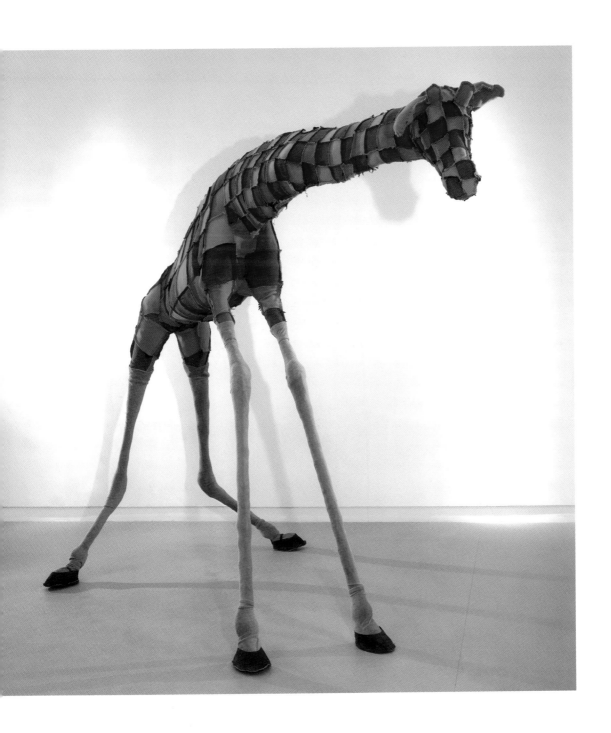

Mark Francis

above:
Positive, 1992
Oil on canvas
76 x 76 cm
Gift of Charles Saatchi, 1999

right:
Untitled (Negative 2), 1992
Oil on canvas
107 x 91.5 cm
Gift of Charles Saatchi, 1999

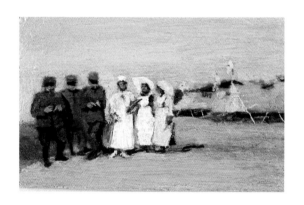

Pamela Golden

above:
Untitled (from the Mrs Watson Pours
the Coffee *series),* 1995
Oil and encaustic on paper
4.4 x 7 cm
Purchased from Gimpel Fils, 1997

right:
*Mrs Watson, Signor Treci and Traldi
at the Hospital,* 1995
Oil and encaustic on paper
4.6 x 7 cm
Purchased from Gimpel Fils, 1997

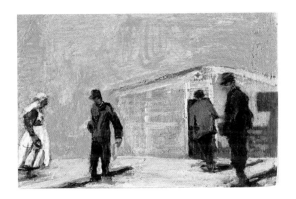

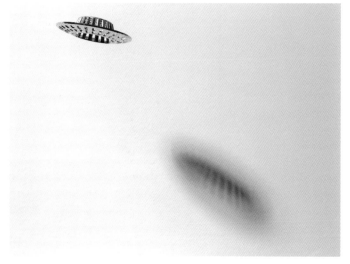

Andrew Grassie
Pleiadian Space Craft, 2000
Metal
6 cm diameter
Purchased from Mobile Home, 2000

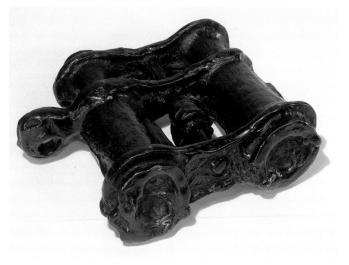

Steve Johnson
Binoculars (charm no.9), 1995
Bronze
9.2 x 25.3 x 21.3 cm
Purchased from the artist, 1995

Michael Landy
Scrapheap Services, 1995
Ink on paper
76 x 56 cm
Purchased from Karsten Schubert, 1995

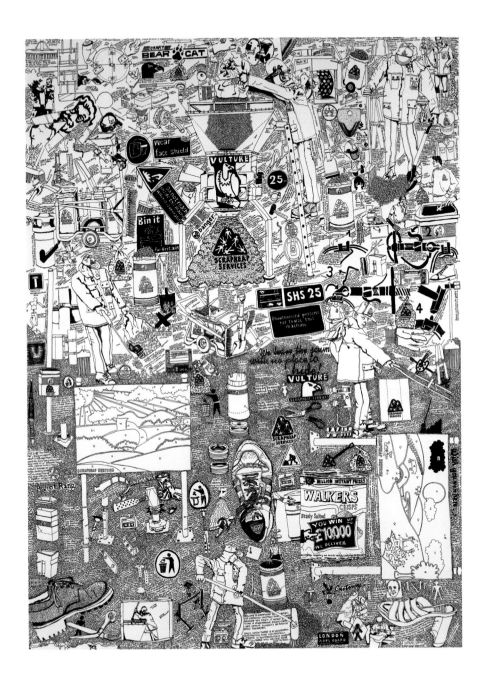

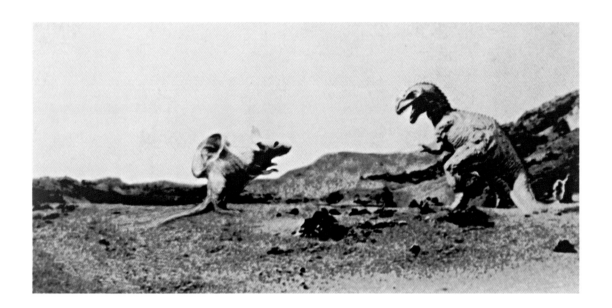

Abigail Lane

above:
Dinomouse Sequel Mutant X, 1997
Screenprint
57 x 88.5 cm
From *Screen*: portfolio of 11 prints
produced by The Paragon Press,
edition 14 of 45
Purchased from The Paragon Press, 1998

right:
Ink Pad 1, 1991
Aluminium, MDF, cotton, felt and ink
168 x 92 x 1.5 cm
Gift of Charles Saatchi, 1999

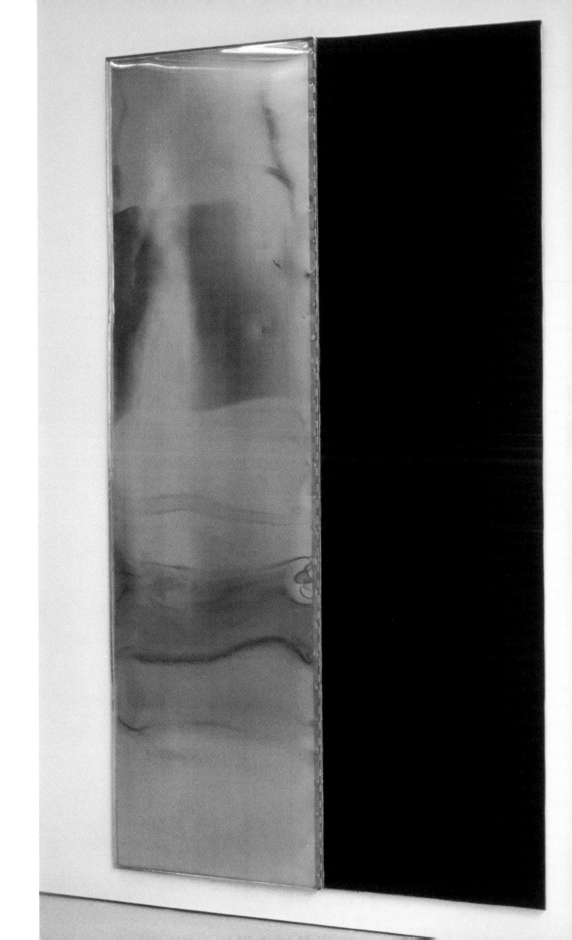

Paul Etienne Lincoln

below:
The World and Its Inhabitants, 1997
24 cards and small booklet in box
13.5 x 8 x 2 cm
Edition 1 of 24
Purchased from Book Works, 1999

right:
The Globexpander –
The Classification of Idle Courses, 1998
Metal, nitrous oxide and mixed media
30 x 10 x 10 cm
Edition 9 of 24
Purchased from Book Works, 1999

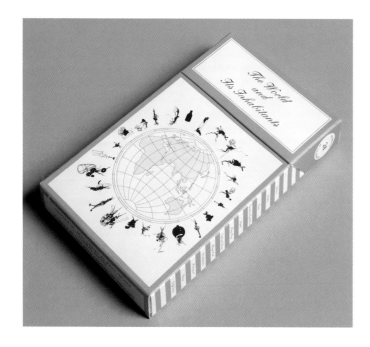

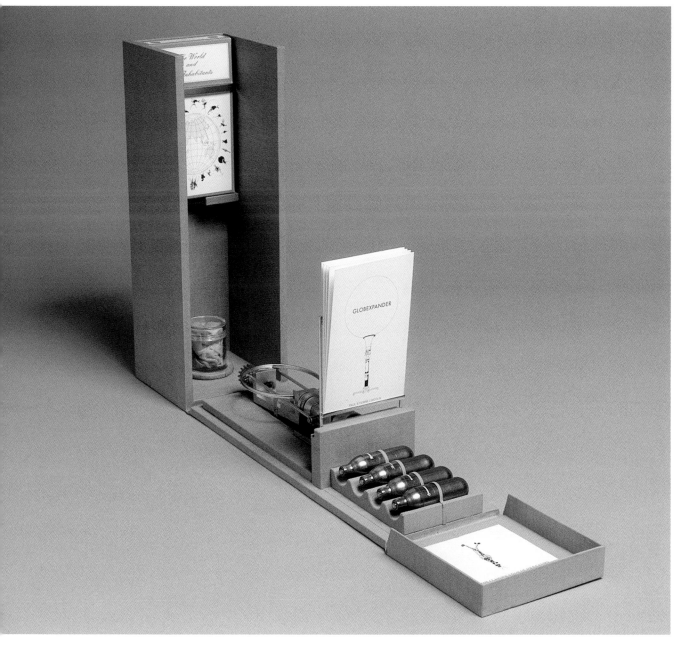

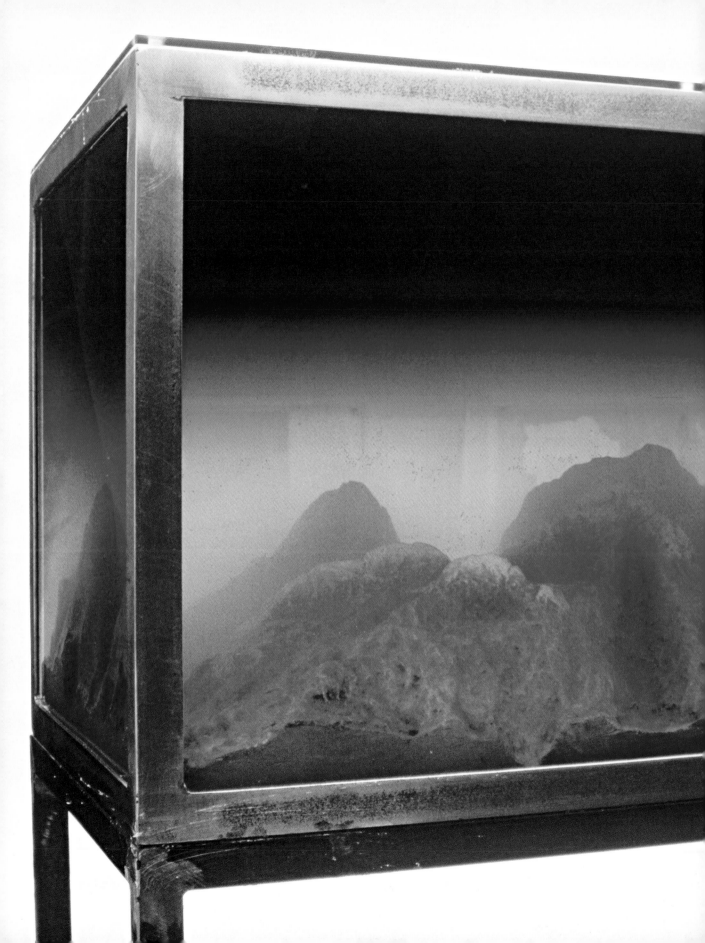

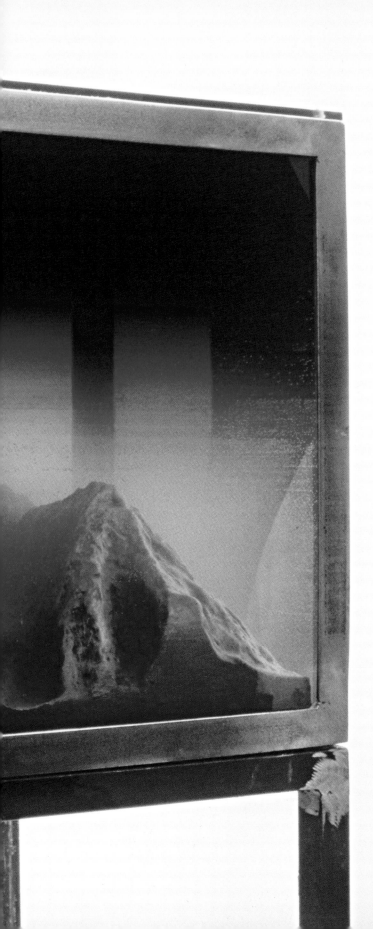

Mariele Neudecker
Stolen Sunsets, 1996
Steel, glass, fibreglass, dye, acrylic,
enamel, water, salt and varnish
180 x 65 x 45 cm
Gift of Charles Saatchi, 1999

Cornelia Parker

below:
Small Thought, 1994
Printed circuit board and silver
components
23.4 x 21.1 x 0.1 cm
Edition of 50
Purchased from the artist, 1994

right:
Fleeting Monument, 1985
Lead, wire and brass pendulums
76 x 214 x 214 cm
Purchased from Air Gallery, 1986

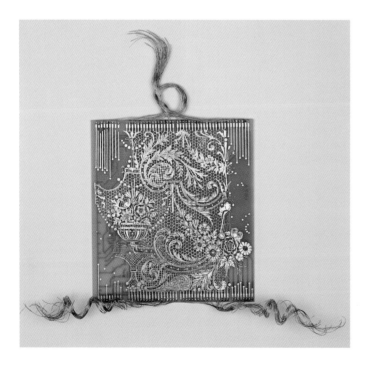

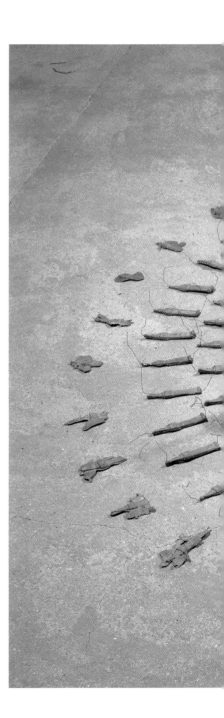

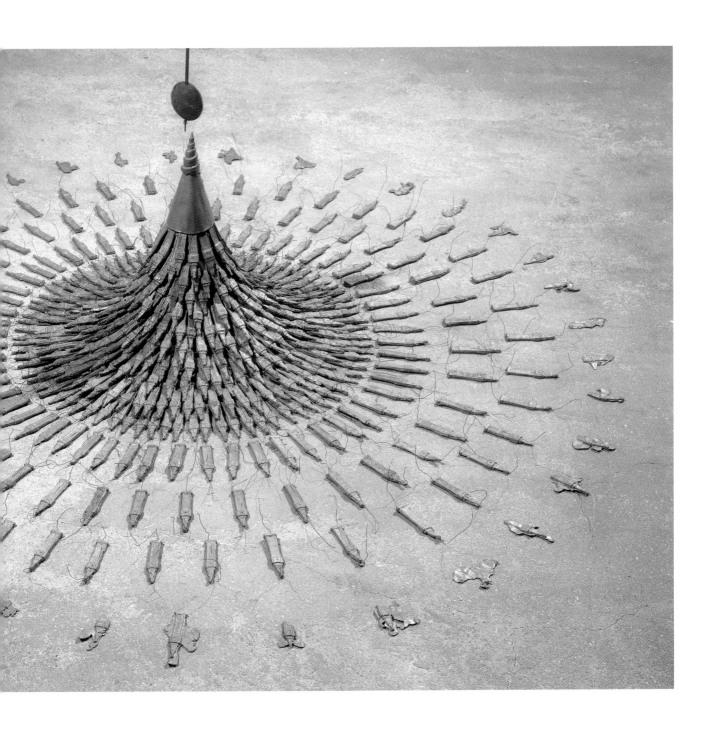

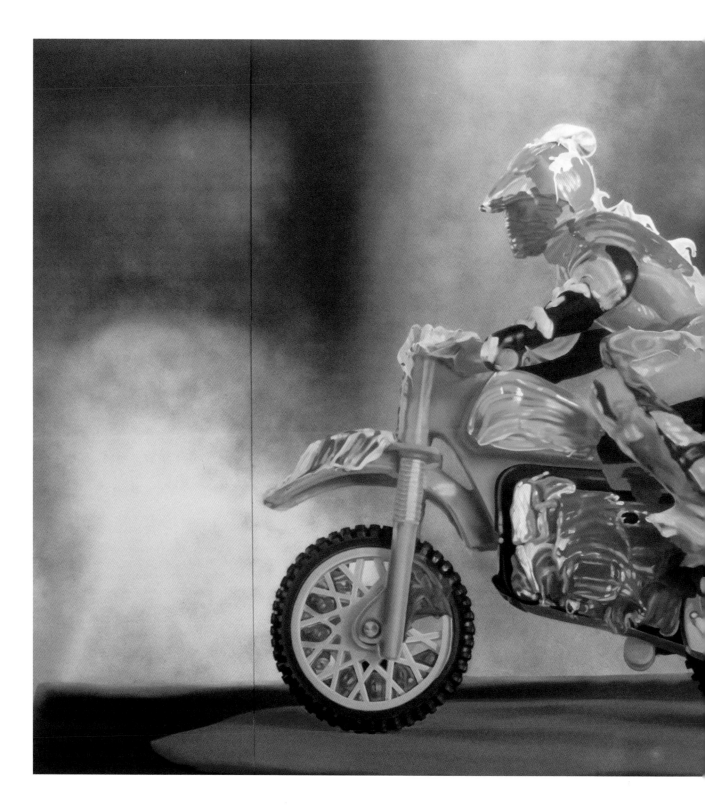

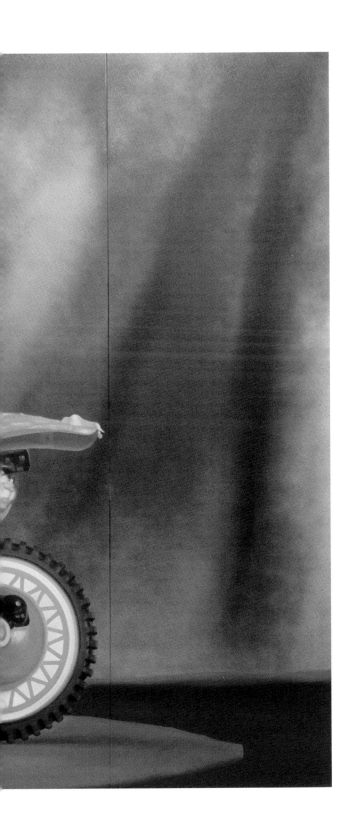

Richard Patterson
Motocrosser, 1995
Oil and acrylic spray paint on canvas
3 parts, total 208.3 x 315 cm
Purchased from Anthony d'Offay
Gallery, 1995

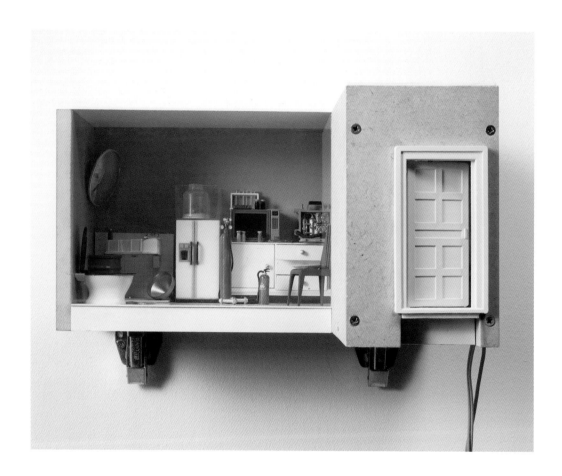

Gary Perkins

above:
Meanwhile, at the Marie Curie
School of Organic Chemistry..., 1995 (detail)
Monitor, CLD camera and mixed media
17.4 x 32.5 x 24 cm
Gift of Charles Saatchi, 1999

right:
-15° C at 60 mph, 1996
Monitor, CLD camera and mixed media
16 x 10 x 55 cm
Purchased from Victoria Miro Gallery, 1997

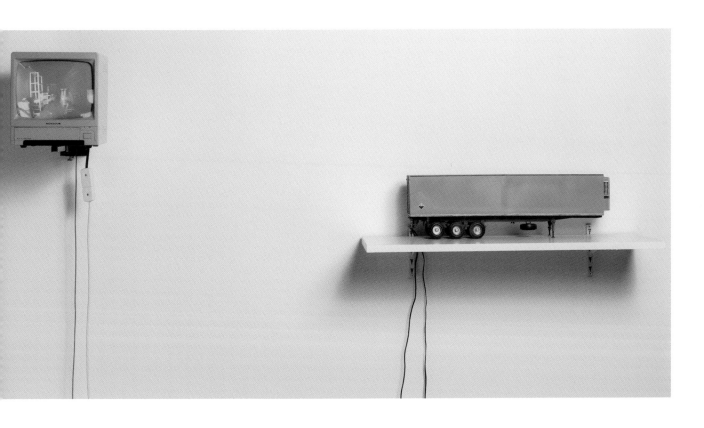

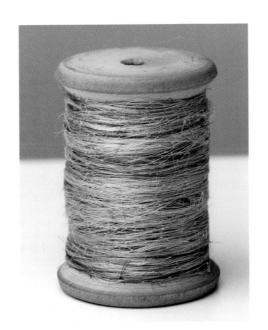

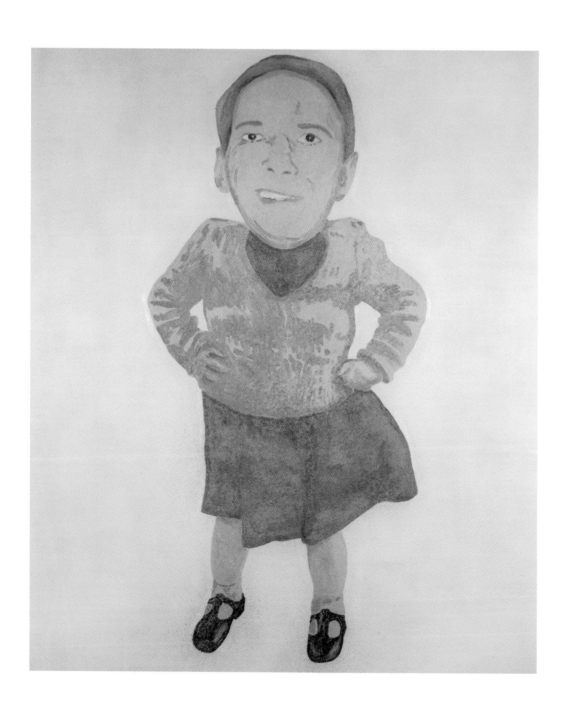

James Rielly
Object of Fun, 1995
Oil on canvas
213.1 x 183 cm
Gift of Charles Saatchi, 1999

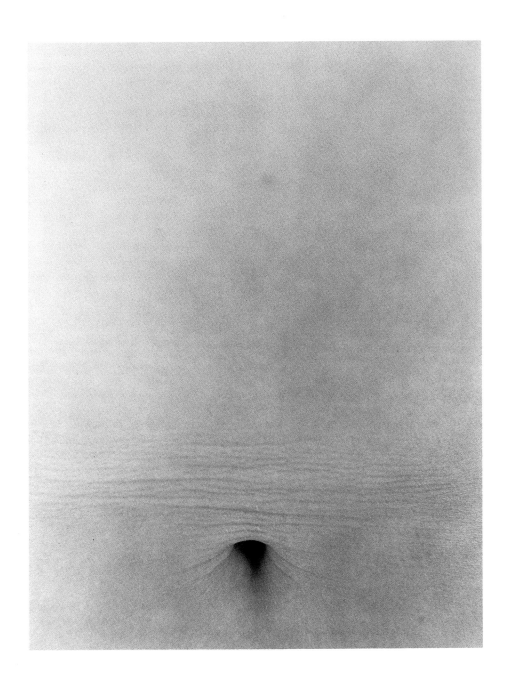

Helen Robertson
Navel, 1994
Black-and-white photograph mounted
on aluminium, printed 1995
177 x 138 cm
Edition 1 of 3
Purchased from the artist, 1996

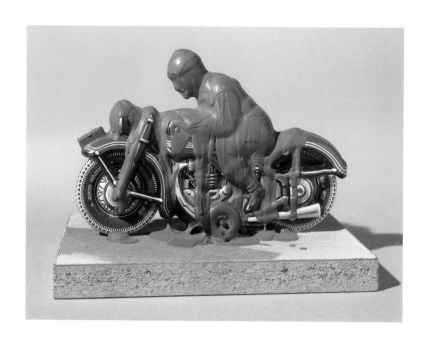

Dieter Roth

above:
Motorcyclist, 1970
Paint and toy motorcyclist
12 x 17 x 11 cm
Edition of 100
Purchased from Galerie Klaus Lupke,
Frankfurt-am-Main, 1970

right:
Pocket Room, 1968
Plastic box, print and banana
10 x 7 x 2 cm
Unlimited edition
Purchased from Vice-Versand,
Remscheid, 1970

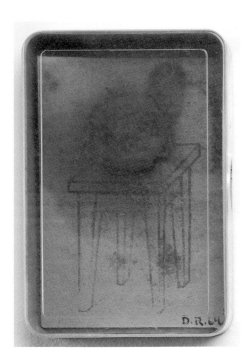

Gary Rough
Space, 1995
Paint, photographs, paper, wood,
glass, metal and plastic
Dimensions variable
Gift of Charles Saatchi, 1999

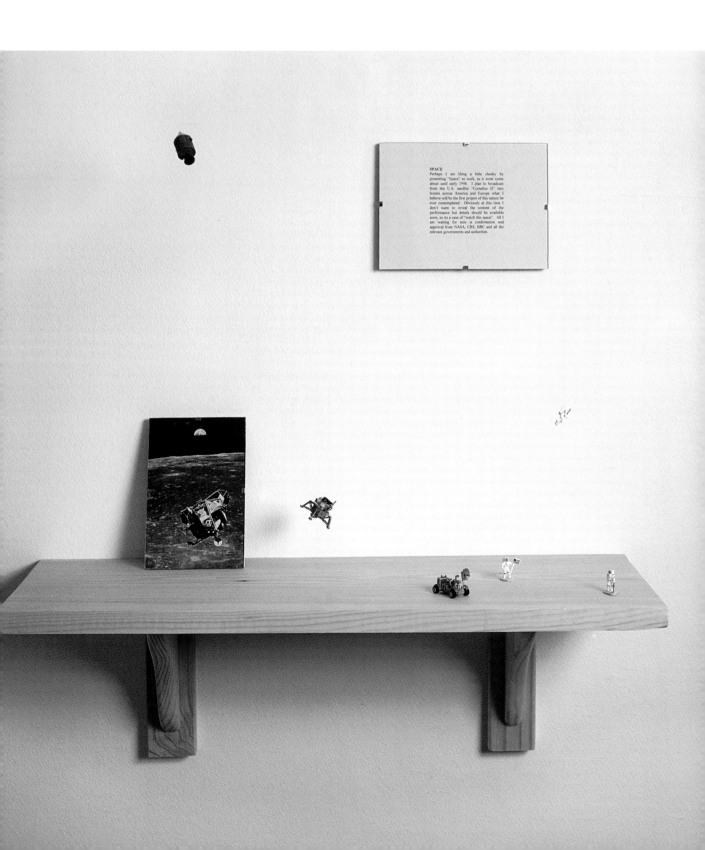

SPACE
Perhaps I am being a little cheeky by
presenting "Space" as work, as it wont come
about until early 1998. I plan to broadcast
from the U.S. satellite "Cornelius II" into
homes across America and Europe what I
believe will be the first project of this nature be
ever contemplated. Obviously at this time I
don't want to reveal the content of the
performance but details should be available
soon, so its a case of "watch this space". All I
am waiting for now is confirmation and
approval from NASA, CBS, BBC and all the
relevant governments and authorities.

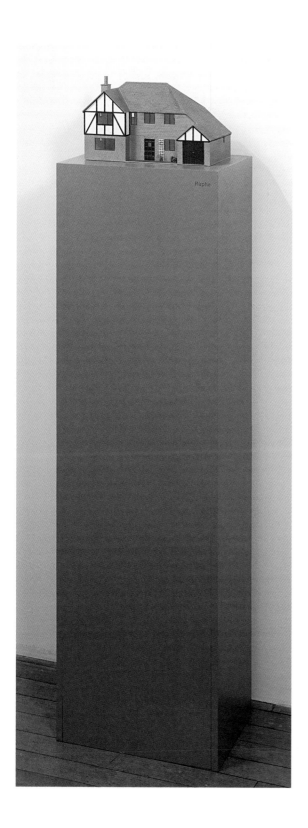

Emma Rushton

left:
Raphe (Businessmen), 1992
Plasticard, printed paper, perspex,
gravel, paint and MDF
114 x 30 x 20 cm
Gift of Charles Saatchi, 1999

right:
Chris (Businessmen), 1992
Plasticard, printed paper, perspex,
paint and MDF
158.8 x 24.3 x 24.3 cm
Gift of Charles Saatchi, 1999

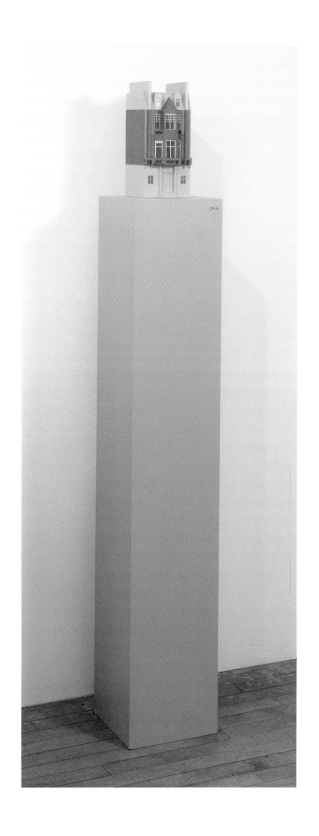

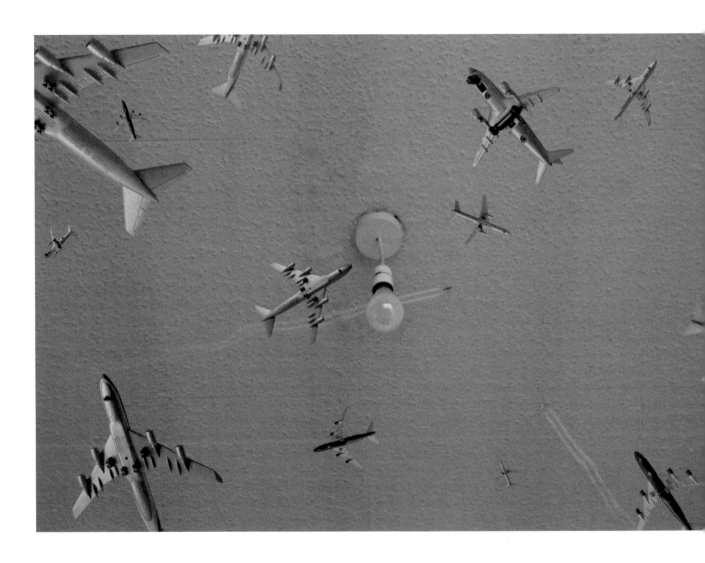

<u>Hiraki Sawa</u>
Dwelling, 2002 (stills)
Video projection
Running time: 9 minutes, 20 seconds
Purchased from *New Contemporaries 2002*, 2002

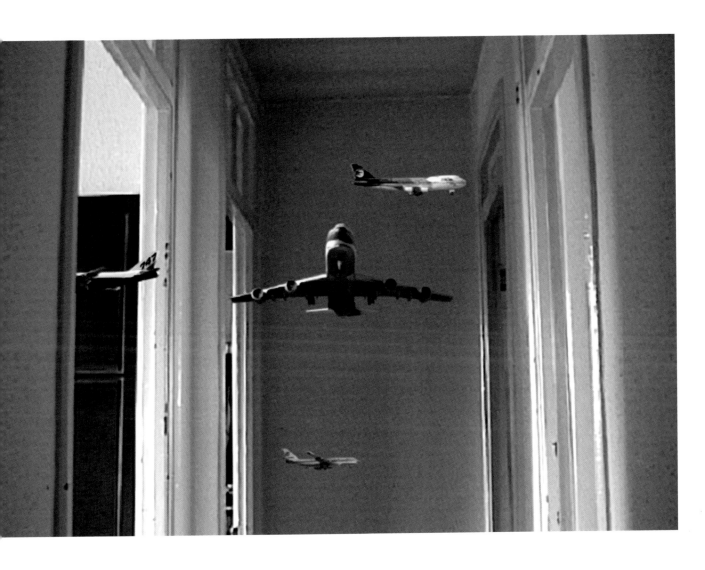

Hilary Wilson
Drawer III, 1990
Wood
9.5 x 310 x 38.5 cm
Purchased from *New Contemporaries 1992,* 1992

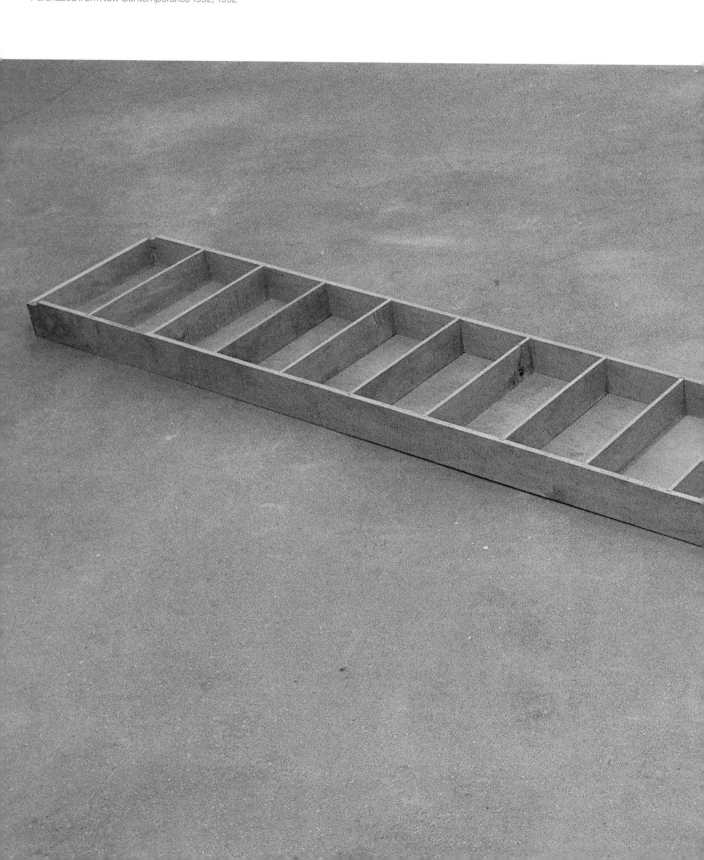

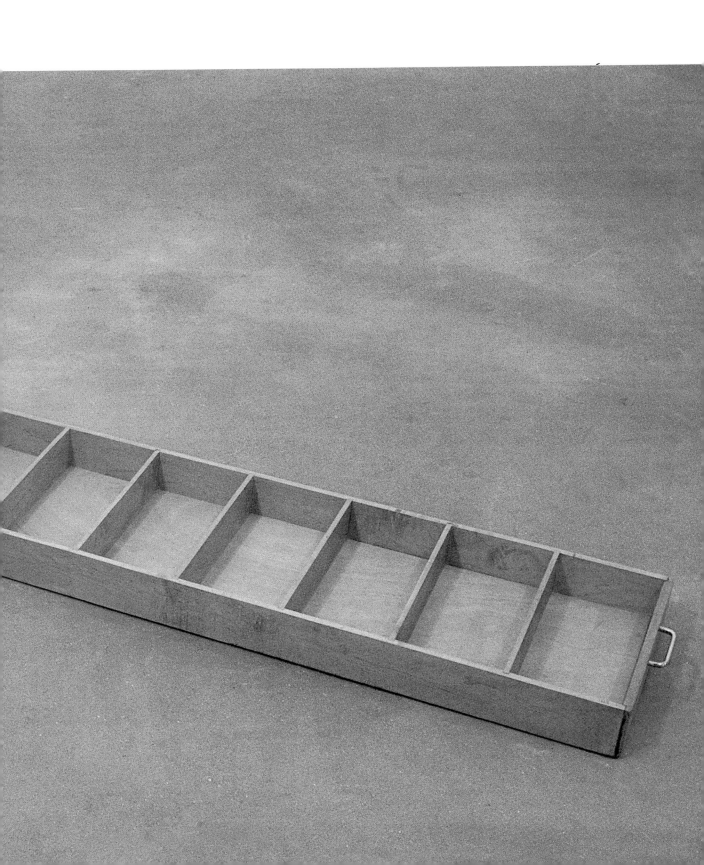

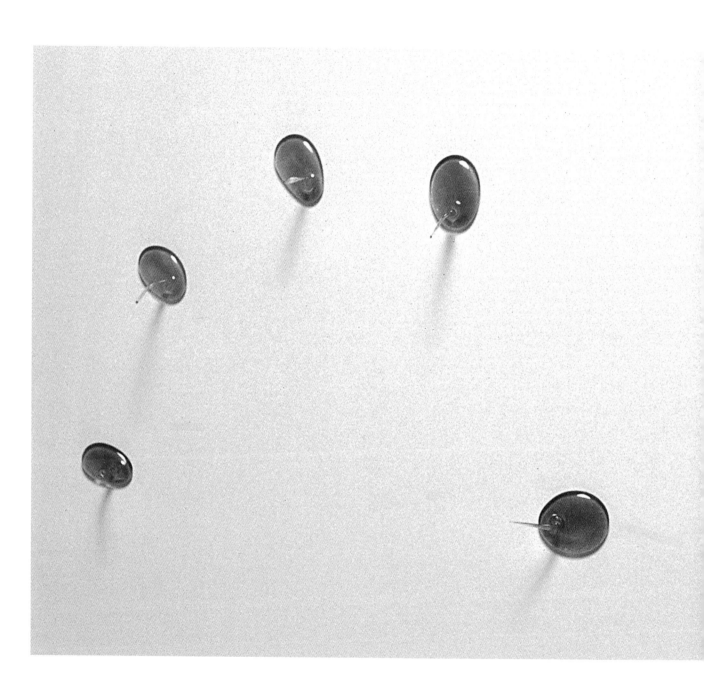

Hermione Wiltshire
My Touch, 1993
Cibachrome photograph, glass,
silicon glue and aluminium
200 x 100 x 40 cm
Purchased from Lisson Gallery, 1993

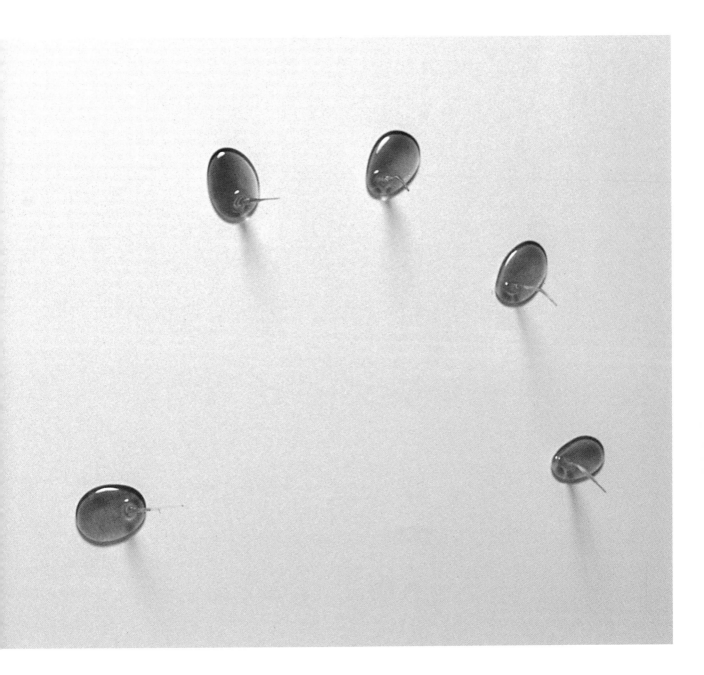

Elizabeth Wright

below:
Untitled: Newspapers and Tesco Bag, 1994
Paper and plastic
2 x 70 x 60 cm
Purchased from the artist, 1995

right:
*Pizza Delivery Moped Enlarged to 145%
of Its Original Size,* 1997
Mixed media
274.3 x 66 x 137.2 cm
Gift of Lux Gallery, 1999; commisioned by
London Electronic Arts to mark the launch
of the Lux Centre

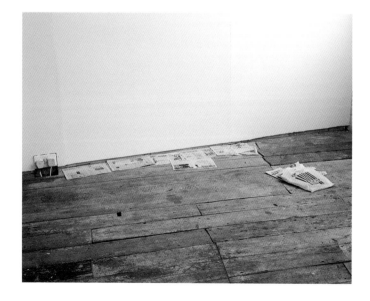

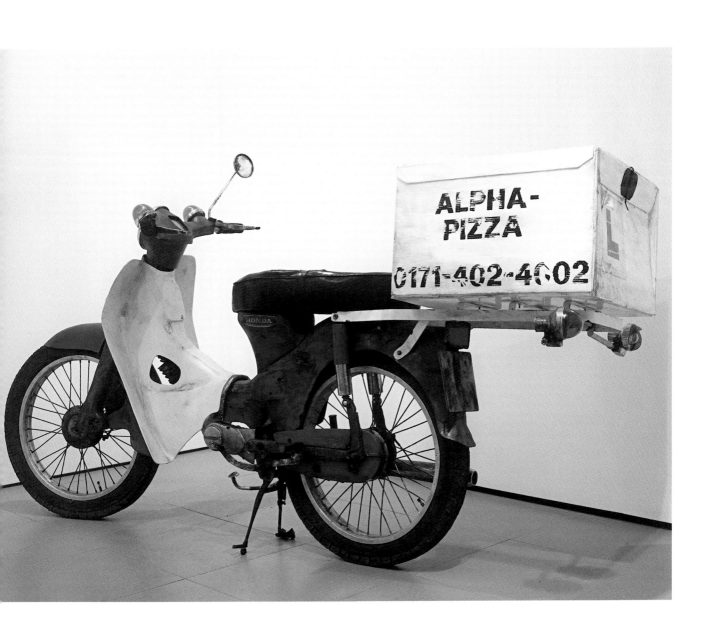

'What a curious feeling!' said Alice.
'I must be shutting up like a
telescope!' And so it was indeed:
she was now only ten inches high,
and her face brightened up at the
thought that she was now the right
size for going through the little
door into that lovely garden. First,
however, she waited a few minutes
to see if she was going to shrink
any further: she felt nervous about
this, 'for it might end, you know,'
said Alice to herself, 'in my going
out altogether, like a candle. I
wonder what I should be like then?'
Lewis Carroll, *Alice's Adventures
In Wonderland*, 1865